Breaching
the Peace

a women's liberation publishing and printing group

Published and printed by ONLYWOMEN PRESS, LTD.,
38 Mount Pleasant, London WC1X 0AP. 1983

ISBN 0 906500 13 3

Cover Design and cartoons by Cath Jackson

Typeset by Leveller Graphics, 52 Acre Lane, London SW2 5SP

CONTENTS

INTRODUCTION

Most of the papers here were written for a radical feminist half-day workshop called 'The Women's Liberation Movement versus The Women's Peace Movement or How Dare You Presume I went to Greenham?' held at A Woman's Place in London on 10 April, 1983. We organised the workshop because we wanted to talk about what was happening in and to the Women's Liberation Movement. We see the women's peace movement as a symptom of the loss of feminist principles and processes — radical analysis, criticism and consciousness raising. It seemed to us that open discussion had become a rarity and the movement rife with intimidation and cliche. Each of us had felt isolated, able to discuss our politics only with intimate friends. We feared that the Women's Liberation Movement would become just another trend, leaving a trail of angry and disillusioned ex-followers in its wake; a quaint footnote to an otherwise unchanged history of the world.

The four of us had attended several meetings aimed at eventually holding a Radical Feminist History conference which would combine the presentation of radical feminist history with its present expression — not history as a 'given', but a radical feminist continuum. These meetings were overwhelmed by both internal difficulties and the size of the task of organising such a massive conference. The four of us continued, however, to discuss what we as individuals wanted to get out of any radical feminist conference and what we could manage. A series of half-day or one day workshops on specific topics seemed possible and perhaps ultimately more satisfying than one weekend conference to cover an enormous range of subjects. 'The Women's Liberation Movement versus The Women's Peace Movement' was intended as the first of a series of radical feminist workshops.

In organising our small conference we intended to reaffirm radical feminism both with the papers presented and through the structure and process. Encouraging women to write papers, writing ourselves and searching out previously written material were the major tasks. On the day, we made sure that women

had time to read the papers. We arranged things so that some women from each of the first workshops would be present in each of the second, enabling everyone to have some idea of what went on in the earlier discussions. The conference went brilliantly. About 100 women participated with what seemed to be lively enthusiasm. Of the papers presented, all but two are included here. This pamphlet is an expression of a radical feminist point of view and we thought it inappropriate to include these isolated token expressions of other politics.

This conference was not the first time radical feminists have addressed the women's peace movement as a worrying issue. Sophie Laws wrote on the subject for Catcall in 1981 and Margrit Shildrick wrote in The Merseyside Women's Liberation Newsletter and in WIRES earlier in 1983. We've included Sophie's and Margrit's essays in this booklet for the additional insights and historical perspectives they offer. For some time women have been discussing the threat to feminism posed by the women's peace movement and these discussions, though not so public and accessible as written statements, have fuelled our conference and this pamphlet. We want now, by publishing these papers, to begin to expand our discussion, to speak of these issues with as many women as possible.

Papers were proposed for the conference which were not, in the end, written and other suggestions grew out of the April 10th discussions. We hope that these essays will soon appear; on the language and language distortions of the peace campaigns, the history of peace struggles versus feminism (ie. the demise of the suffragettes), the effect of the women's peace movement on feminism in rural communites, style as a substitute for politics (Rock against anything at all), distinctions between radical feminist, revolutionary feminist and socialist politics vis a vis the peace movement.

As radical feminists we want to address a host of other issues. This pamphlet is one step towards more radical feminist discussions, papers, workshops, conferences, actions.

Brenda Whisker
Jacky Bishop
Lilian Mohin
Trish Longdon

6

NOT WEAVING BUT FROWNING

Towards the weekend of 11th December last year the realisation gradually dawned on me that I was one of the very few women I knew who weren't going to Greenham Common, I mean those who had a reason not to other than having flu. i.e. who positively chose not to. I hadn't realised I'd made that choice, it had never even occurred to me to go, I didn't even consider it. So I thought I'd write something down now about my reasons, as they've become clearer to me since meeting with incredulity. What surprised me was other women's surprise. 'You're not going to Greenham Common?' said with disbelief made me an object of some alarm. Was I for cruise missiles in Britain? Perhaps I believed in war? Was I unaware of the enormity of the threat of annihilation of spaceship earth, ignorant of the facts, or did I just not care passionately enough about the continuation of the planet? (Even my father was stunned — perhaps I'd seen the light about the Russians at last.) Then I must be one of those nit-picking little radical feminists who just go around criticising all the time, for whom nothing is ever politically perfect.

I was depressed as well as surprised by women's reactions, because I'd been unconsciously taking something for granted, when actually the assumption was working the other way. I don't feel I ought to need to explain myself to other feminists about this. But the issue of guilt creeps in here because there does seem to be an assumption floating in the air that Greenham is where it's at, and there's an element of unquestioning acceptance of this that I think makes it hard to discuss it critically, which makes me uneasy and angry. I see the current development of the 'women's peace movement' as it's come to be called, not as a widening out of feminist struggle but in the context and as part of the liberalisation of feminism and the decline of the Women's Liberation Movement over the past few years. Women are now doing many things together, but this of itself is not necessarily feminist — whatever it is, the mere fact that it's women doing it is not enough, if it does not have feminist analysis, process and aims. Greenham Common looks like the acceptable face of women-only actions to me — legiti-

mised by its falling into women's traditional role of concern for future generations, pacifying etc. Women being together "merely" for the pleasure and need of it is not. So, it's OK to link arms and hold hands around a military base in the cause of peace, but do it on the streets for the love of it and it's another matter, as any dyke who's been beaten up can tell you.

The possibility of actions like a womens peace camp rests on the work of feminists who have struggled for years to establish womens right to political and personal autonomy. And meanwhile our actual continuing fight for that autonomy, and what small gains we have made, are under constant threat from all sides. Our women-only resources, spaces, events, housing, meeting-places, etc are eroded and always under attack. If this sounds alarmist, so it should, I feel very alarmed. Our resources are few and flimsy. Whatever we achieve we have to take for ourselves and then we have to fight to hang on to it. Our housing, spaces and jobs are threatened with prosecution under the guise of the 'progress' towards equality and non-sexism. Our lives are threatened, our children are taken from us, we aren't supposed to exist. Women-only events — conferences, workshops, socials — decline in number, cooption and liberalism abound. And separatist-bashing continues as the pastime of right, left and liberal. For after all, it is our self-chosen separation, our assertion of our right to autonomy, that is still at the heart of the matter, as ever. Women bonding, choosing each other, rejecting and absenting themselves from men, is still as taboo as it ever was — if it is for ourselves. But if it's for a "bigger" cause, it's OK in some way. They may belittle it in the newspapers, but it still makes sense in *their* terms.

Surely we should be wary of phrases like "greater cause" and "ultimate act of male violence". They get used a lot and make me very pissed off. And isolated, because there must be a huge gap between the way that I see the world and the way (some) women in peace campaigns do. On one level — or according to one hierarchy — of course it makes sense: a total and final destruction is an ultimate act, can't quibble with that. However,

to leave it there seems to me a big failure of analysis/vision. Because women are always having war waged upon us, and I am not using the word metaphorically. Your definition of war I suppose depends on what you perceive as atrocity. Because the violence of this war is so widespread it is not seen as such by many of its victims and certainly not defined as such by those who do the naming — the war makers. It's the very fragmented and personalised nature of the war against women that allows it to be so normal as to render it invisible. Realising this, linking personal experiences of the institutions of rape, battery, abuse, marriage, heterosexuality, pornography, mutilation, murder, prostitution etc. etc. into a collective understanding of women's oppression forms a basis of consciousness-raising. Through feminism we have come to see that, as Kathleen Barry puts it in "Female Sexual Slavery": "The huge number of men engaged in female sexual slavery should be cause for declaration of a national and international emergency, a crisis in sexual violence. But what should be cause for alarm is instead accepted as normal social intercourse." As far as I'm concerned the ultimate act of male violence happens everyday. And when I am walking around thinking of this and I hear phrases like "women for life on earth" and "women for peace" I feel completely bemused. What on earth do they mean? What peace? Being "against cruise", "against nuclear arms" I can understand, but what is this idea of "peace"? Is it the absence of nuclear weapons — which could not mean "peace" for women who are fighting for their very existence through no choice of their own in wars, military or otherwise all over the world. If it is perhaps the peace that could only come from feminist revolution, which radically and completely changed the world, then why not call for *that* revolution?

These are just some of my thoughts on this issue. I don't assume that the women in the peace "movement" all have the same politics. I would like to see much more discussion about it all and less defensiveness about being critical. My own feelings on the issue have changed since about three years ago, I read a lot on the current situation re nuclear war and nuclear power and was so overcome with a feeling of urgency and horror that — I confess — I went on a march and considered joining a WONT group.

Somewhere between Hyde Park and Trafalgar Square I was overtaken by a great unease. I'd been in CND in the 1960's and was incredulous to find myself there again, albeit in a woman's contingent. After 10 years of radical feminism had I suddenly changed my beliefs about the naive futility of such action? My unease crystallised into paralysis and was further clarified on reading Sophie Laws' "Open letter to women in the peace movement" in Catcall. I had narrowly escaped working for the "greater cause", and with relief found that other women were asking the same questions and felt positive about talking about them. I do understand the persuasive appeal of numbers — huge masses of people against us — as they perceive it — huge threat, but I find it a false appeal, as well as being a male, straight method of political organisation. I feel sad rather than moved when women talk about the amazing feeling of so many women together — of course I know that feeling, it informs my whole life. But I feel so cynical about the illusion of power it can create. 30,000 women can encircle a military base, but within this patriarchal society one single man has so much power that, with the male state behind him, he can, as the father of my friend's child has done, with effortless ease wreck and totally negate a woman's whole life and ten years of childcare and work. The next time one man uses the anti-lesbianism/misogyny of the world to take away the custody of a lesbian's child I would like to see 30,000 women marching to, on and over him. And until men stop oppressing, killing and waging war on women, I, for one am not going to include them in my definition of "life" or wish any one of them one moment's "peace".

frankie green

GREENHAM COMMON AND ALL THAT . . .
A RADICAL FEMINIST VIEW

Originally submitted to 'Scarlet Woman'.

I have some serious doubts and disagreements about the politics of the women's anti-nuclear campaigns and their compatability with feminist politics and aims. I am writing as a radical feminist who has not been involved in the actions or the organisations, but I want to comment on the impressions which come through the media of these, and make one or two more general points also.

I understand that Greenham Common etc. claim to be women's campaigns and not feminist ones. What distresses me most about them is the image of women that is coming through as the symbol and justification of these movements. On the T.V. and in the newspapers I see women saying that they are here for the good of their families, that they are simply "ordinary" women who are deeply moved by the urgency of the situation, that they are "naturally" concerned to preserve life and defend their children, that if there was no nuclear threat, they could go on being nice, ordinary women and all would be O.K. I'm sure you can see from this the stereotyping of women which — granted, it is coming thro' the media — but is also deeply interwoven with the politics and tactics of the women's protest and perpetuated by many of the participants. I was disturbed to see a picture in the newspaper (it was the Guardian in January) of a Greenham Common woman giving her blessing to the statue of 'Peace' outside the G.L.C. The statue looked like a 60's model, young, thin woman in shorts with long, straight hair (obviously white), holding a dove. The airforce base is "embraced" and covered with (mostly) baby clothes and pictures. All this is precisely the kind of protest that is expected of and allowed to women. It is the traditional voice of the poor woman left at home who can only use emotional appeals (on *others*' behalfs) to influence those that do have power. Popular press attitudes (the favourable ones!) take the view that they really must start to take some notice . . . if the 'real' women have come out of their homes — they'd better be pacified again.

This 'ordinary' woman (and she is only 'real' if she is 'ordinary') is the heterosexual, white, married-with-children housewife — the appeal depends upon that image to be taken seriously. I know that feminists and lesbians, the childless and black do participate, but that's not the point here. Every time this 'ordinary' woman is held up, those of us who are not her are betrayed. The approved version of all women which feminists have been struggling to destroy is constantly reinforced. This is not accidental, it is crucial to the politics involved, that is, for the appeal to have credibility it must come from a respectable source. This reinforces the assumption that women should and mostly do conform to those stereotypes. It also implies that those who do conform are not oppressed other than by the possibility of nuclear war. Being women-only doesn't make the campaign a feminist one, on the contrary, the ideas behind this kind of organising are actually in opposition to feminist aims.

The idea that women are naturally non-violent, could not be responsible for wars and the development of nuclear technology, that is, wouldn't even if we had access to weapons and science; that it is a particular female characteristic to respect life — this is a dangerous one for us to hold. It goes along with some biological notion that we inherit our behaviour with our genitals or that we are protectors of life because we bear chidren and that this is right and proper. This is odd, both coming from women whose intention presumably is to influence men and/or those women who very definitely don't conform to this image. It is a self contradictory position for the feminists who are involved, since it is precisely that polarised construction of masculinity and femininity which they analyse as, at least, partly responsible for the problems of the patriarchal development and use of nuclear power in the first instance. How can you influence men if such matters originate in masculine biology? It would seem a losing battle either way.

It is highly suspect for women to be basing any claims on their supposed link with the natural. Yes, I too feel turned-on by small, furry animals and mountain scenery, however, I feel no particular affinity to the tapeworm, or the male of my own species if it comes to that. I would remind everyone that the

smallpox virus is as natural as the panda, but no-one calls it an endangered species! The point is, that our idea of what's natural is highly selective and inconsistent. The point is that we shouldn't be using that as some given, unquestionable criterion. Surely we've learned our lessons about the way that the so-called natural has been used against us. To base a campaign on that kind of (largely unspoken), but strongly present feeling is not only double-think, but it is not in our interests as women and therefore likely to have reactionary rather than radical consequences.

Instead of being panicked or guilt-tripped into thinking that we have to save the world from imminent destruction it's important for us to consider what creates these situations. Instead of fighting repeated, rearguard actions which use all our resources and don't alter the balance of power, we should be working solidly against the underlying structure of patriarchy. Women's oppression is fundamental to maintaining the system which is the backbone of our oppressive, destructive society. It is not a secondary issue to be attended to 'after the revolution', or after you've saved the world. You can't do either without it. To undermine women's liberation in such a project is therefore self-defeating. In the small town in which I live, the anti-nuclear activities are the ones which attract the most women (apart from therapy, that is). It is, of course, arguable, however, whether these women would have been interested in joining feminist groups, and we have to face the fact that many of them are not.

It is still difficult, it seems, for women to take their own oppression seriously, to see it as important and urgent for its own sake. It's always easier to say — it's for the children, or for someone less privileged than me, etc. etc. If we don't take it in hand, no-one else will, and despite protest, the real powers in this society will not *radically* alter in the ways that would make life as well as surviving possible.

The politics of single-issue campaigns such as these and CND (a prime example) are rather dubious too. They depend upon wide appeal, the lowest common denominator not only in

terms of attracting large numbers, but importantly in determining their aims. Of course, no-one wants to be blown up by a bomb, of course, I'm in favour of 'life on earth' (though I like some bits of it better than others). It becomes meaningless clichés on that level — what you are going to do about it; what it itself is — as soon as you get down to the nitty gritty, political disagreements ocurr. It's like trying to do politics without the politics. Remember the Peace People in Ireland? They failed because although in theory everyone wants peace, they don't necessarily want it at any price. You have to carve out a political analysis to organise, to be effective — you can't depend upon vague good intentions and a large show of bodies. Yes, the anti-nuclear campaigns might be said to have influenced Labour Party policy, but I would remind us again that the Labour Party has betrayed the disarmament cause before, and will again if it costs them too many votes.

Anyway, the point I want to make is about not sacrificing feminist aims simply in order to attract large numbers of women to these campaigns on the basis that somehow that in itself will count as a feminist gain. It doesn't in my book, any more than the women's institute represents feminist organisation or a mixed CND or Labour government represents a serious challenge to patriarchal power.

A final couple of points about violence and demos. I've heard it said that the point of these demonstrations being women-only is to keep them non-violent because women are non-violent and hence will not provoke violence from the police. This simply isn't true. I won't go into the awfulness of the gentler/feebler sex business again, but would like to point out that the police will attack demonstrating women if the cameras are not on them. There have been violent police actions at non-violent, women-only Reclaim the Night marches. Are we to take this as our failure? Perhaps we didn't have enough "woman-magic". It is highly dangerous for women to rely on their moral superiority to protect themselves from men. We should not perpetrate this or the myth of chivalry. Just be prepared for the time when the campaign is not the latest media darling, or when they decide that none of you can be 'real' women or you

14

wouldn't be on the street, lesbian, black, uppity, wearing trousers, shouting. . .

Lynn Alderson
February 1983

Postscript:
Since I wrote the above, we have seen the start of a new movement called "Women for Defence". It has set up specifically in opposition to the women's peace movement and is, or was at its inception, made up exclusively by Conservative Party women who support the government's defence policy. It is no surprise, however, that the values they express and the reasons for their campaign are very similar to those claimed by the "radical" women's peace movement. That is, it is in defence of their families and homes and they see themselves as the true 'peace' campaigners. I don't think they are a force to be taken seriously, but I do think this illustrates well the political confusion which arises from such generalised appeals, and the essentially conservative nature of women organising along lines demarcated by the traditional notions of womanhood rather than in direct opposition to them.

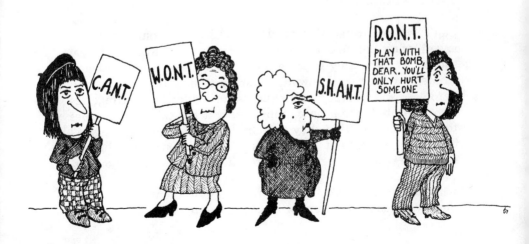

At Christmas I saw the 30,000 women who joined hands and celebrated at Greenham Common on the TV. It made me feel warm to see so many smiling women, to see the impact of large numbers of women acting together, to feel our strength.

Why wasn't I there? It would have been so comforting to supplement my daily struggle against my oppression, my feelings of how small our movement is, with the exultation of being amongst so many. And to savour the acceptability of being part of the peace movement. Even my family could have told their friends that I'd been at Greenham Common — a pride they don't feel when I'm confessing I work at the Rape Crisis Centre. At Greenham, breaking the law, occupying hillocks, lying down in the road were almost smiled upon by the largely benign and sympathetic press and police. Attendance at court became a fete. Yet one egg thrown at the screen of cinemas showing 'Dressed to Kill', or a reclaim the night march — small glimpses of the anger of women — are condemned and severely punished. At Greenham we aren't shrill, aggressive, short-haired, man-haters but peace-loving, idealistic givers of life.

I am not sure that this acceptability is because at Greenham we are not naming our own oppression as women but have been co-opted into male struggles, accepting their terms and receiving in return their approbation and status. It shows the depth of our oppression that naming it and fighting against it is not even a valid political activity.

Can't we see what they're doing? Absorbing our justifiable anger, using our fear and directing them away from their real source — where they might grow — where men would lose and women would win — towards their own ends. It has happened before — and proved a very successful tactic. The suffragettes were co-opted into a peace movement. It has taken us decades to regain the position they thereby lost. Must we lose it again? The peace movement is a means of diverting us from the real struggle — our struggle. Men, by dividing us can weaken us.

What about process? In the women's movement we focus on ourselves, rediscover our own experience, name it, share it with

16

one another and build our theory. We take control of ourselves. Take and create our own space. Women in the peace movement are asking things of men, the holders and wielders of power, not only militaristic but economic, social, legal etc. They take part in organised demonstrations, the men let them, they make the food and take care of the children. It is clear to me where the real power remains. Yet there is a widely held assumption that the peace movement is about women's liberation. That makes me angry. Where has the questioning gone? Where is our feminist analysis? Where is our feminist process?

Yet I've been accused of inactivity. While I'm doing my CR they're saving the world. At my most incensed I'm tempted to ask 'For what?'. So male violence against women can continue? To support male power? At my saddest I ask 'Are you?' Yes — fighting our oppression as women will take a long time. But surely our daily knowledge and experience of our powerlessness as women points to the futility of asking, or even demanding men to change. Why should they? I see no reason why the nuclear issue should be an exception. I don't think it will make any real difference.

But one thing I do know is that Greenham represents the visible side of women's action. If you're feeling frightened or angry where else is there to go? what else is there to join? The women's liberation movement wasn't easy for me to 'join'. I don't know many women who found it so. We're hard to find — and it's hard work when you find us. Picnics and bus rides are thin on the ground. It's a daily struggle.

I'm writing this because we need to look at women's liberation and the peace movement. We need to be clear in our analysis of what we're doing and why we're doing it. We need to take back our energy for our struggle, talk, write, make ourselves visible.

Trisha Longdon

IS GREENHAM FEMINIST?

Greenham Common continues to occupy an increasing amount of women's time and political energy. It is time to open a serious debate about some of the issues that worry many feminists about the Women's Peace Movement. Why are so many women, feminist and non-feminist, getting involved in supporting Greenham? There is excitement and obvious solidarity of women in their action at Greenham. Is this the same as the strength we derive from the consciousness raising around our common experience that leads to feminist political activity? Is women's solidarity the same as feminism? Is there a danger that, in dancing around the symbols of male, militaristic technology, we are diffusing the energy we may need to recognise and deal with a more physical manifestation of male supremacy and violence: the man next door?

Women may be attracted to Greenham, and the Peace Movement in general, for many different reasons. The prospect of nuclear annihilation frightens us all, although we may perceive it and react to it in different ways. Some women may be attracted to what some of us see as a media constructed "respectable and responsible" face of Greenham that emphasises our roles as mothers and nurturers, intent on saving ourselves and our babies from the Bomb. Others may stress the collective spiritual strength of women in spinning a 'web of defiance' around the destructive force. Many women also take to Greenham the basic principle of autonomous women's action, with an analysis that incorporates a lesbian feminist understanding of male violence and sees Greenham as an important part of the fight against it. Socialists and anarchists may see the Peace Movement as one way of highlighting and combating the dehumanizing and alienating effects of a class ridden capitalist society.

Whatever the differing motives of women involved in Greenham, some women must share some anxiety in operating under the media constructed banner of the 'Public Image' of Greenham women, with its emphasis on traditional feminine values,

18

and its obviously reactionary reinforcement of the stereotyping of women. There are many advantages in cultivating the emotive significance of nappies and toys on barbed wire fences. The ensuing positive publicity fosters respectability as pregnant women are dragged away by reluctant policemen. This emphasis on the strength of traditional feminine attributes as a weapon in the fight against the siting of Cruise missiles has been justified by some as a necessary part of an attempt to attract as many women from as many backgrounds, classes and ages as possible. (And the fact that the Greenham cult has apparently succeeded in attracting many previously unpoliticised women has on occasion been held up as some sort of indictment of the W.L.M.) However, if WAVAW, for example, were to use the rhetoric of the Festival of Light or the National Viewers and Listeners' Association in order to make acceptable and respectable our political views on pornography, we would be rightly condemned for misrepresenting feminist politics, and for making a dangerous alliance with anti-feminism.

We are also concerned that, historically, feminism has always been co-opted and diffused once it has appeared to achieve some of its immediate aims. Between 1914 and the second World War the energies of many militant feminists were redirected into the 'greater threat' of impending war (as pacifists or pro-war nationalists). The achievement of legislative changes led some women in the 1920's to believe that they had achieved the goals of feminism. These women called their retreat from feminism the 'new feminism' and poured their energies into 'human' as opposed to feminist campaigns. It could be that a similar situation is developing now. By the end of the 70's some privileged women had acquired material and professional advantages which led them to believe that they had achieved equality. In the 1980's something called the 'new feminism' is being promoted by women such as Betty Friedan and magazines like Cosmopolitan, Company etc. Is Greenham part of this 'new feminism', i.e. a 'feminism' which appeals equally to women and men? Are women's attention and energies being diverted into the threat of nuclear war — a threat which was no less real in the last two decades than it is now, with women's needs no less real now than they were then?

We too are conscious of, and frightened by, the possibility of nuclear annihilation, but find it difficult to equate the politics of Greenham with the politics of feminism. These are some of our observations and reservations:

1) The Target. The aims (i.e. no Cruise missiles) and objectives of Greenham are more readily identifiable than those of post 1970's feminism which has moved on from the simple platform of the 7 demands in response to the increasing visibility of lesbians, black women, working class women, Jewish women etc. Women's anger and energy, absorbed into dealing with the nuclear threat, may compensate for a disillusionment with the possibility of finding sisterhood now that the cosy bonding of white, heterosexual, middle class women in the movement is being dissolved. Does the Greenham cult recreate these cosy bonds? It may also sidestep the awkward questions raised about men by the fight around male violence and the questioning of heterosexuality.

2) The Threat. Dealing with the threat of nuclear destruction seems to supercede all other political activity. In the face of imminent death, feminism can be portrayed by some as a self indulgent luxury. So Greenham can powerfully appeal to the stereotypical, socially reinforced 'altruism' of women as a cause bigger than the woman herself — a demonstration of women's apparent willingness to suppress their own needs and ends in order to ensure the future survival of 'humanity'.

One of the consequences of this is that the struggle of the WLM is being diluted as women fight a 'superior' issue. For us as revolutionary feminists this is the core of our political misgivings about Greenham. The identification of an anonymous, overwhelming militaristic threat can and does divert our attention from the all too familiar threats of male violence and dominance in our homes, at work, in the streets, schools etc. The lives of one woman, ten women or all women are not changed by 30,000 women surrounding a military base. We see the threat of nuclear technology as only one symptom and symbol of a male supremacist culture. Do some women prefer to put their energies into attacking the symptom they can see, rather than

20

the fundamental cause, which is perhaps too dangerous to confront i.e. the man next door.

The basis of feminism has always been working outwards from our everyday personal experience and fighting male supremacy at a grassroots level. Feminists at Greenham explain that pre-feminist women who get involved often begin to see the feminist implications for their everyday lives and relations with men. This seems an odd justification for Greenham as a feminist cause. Up till now feminist causes have been the implications themselves e.g. housework, childcare, wife-battering, rape. Why are we now retreating? Is direct feminism so weak and irrelevant right now that women have to be politicised indirectly? Shouldn't we be strengthening the relevance of direct feminist issues now when feminism is under threat instead of side-stepping them?

Some Greenham supporters also say that they are raising the issue of male responsibility for the nuclear threat and see the nuclear threat as just one form of male violence. If this is the basis of many feminists' involvement in Greenham why is this not coming out in the public image? It would be good to know what the internal debates and struggles going on at Greenham are. How do the feminists involved feel about the public image and why are no feminist politics coming across either in the media or in the movement? What we need is a debate about feminist politics and the nuclear threat. Could we have this political debate instead of Greenham being viewed, as it seems to be in Greenham circulars and publicity, as a self-evidently important cause for feminists which no longer has to argue its case.

<div align="right">

Some London Revolutionary Feminists:
Linda Bellos
Carolle Berry
Joyce Cunningham
Margaret Jackson
Sheila Jeffreys
Carol Jones

</div>

Women have been telling me that the peace movement is 'mixed' and therefore not O.K. Then they tell me that a women's peace movement is, by virtue of its women only nature, feminist. Then there are women who say that nuclear power is a manifestation of male power, so anti-nuke stuff must be feminist. What, then, do these women understand by feminism?

Women are together without men in the Women's Institute, in the launderette too. But there, as at Greenham Common, they are together for a purpose which is not only acceptable to a male dominated world but which adds its bit to maintaining the status quo for women. Sure, being in any all women situation feels good. Women together *on behalf of women* feels even better.

When the women's liberation movement began to organise autonomously there was an immense sense of exhilaration among us. Much of that excitement, that energy, was generated by being in the exclusive company of women, exclusively FOR women. Everywhere in recorded history there are women only activities, tolerated and even encouraged. After all, it's seen that women may feel intimidated by men, may feel unable to cope, have special capacities. Certainly, they can work best together at their women's work — in menstrual huts, in purdah, making jam, spinning and weaving, having babies and caring for them, being the custodians and understanders of LIFE (that's why women make such appropriate social workers and teachers) and saving the world from nuclear disaster, making it safe for children and for men. When we are together, women only, because we love each other only and because we are working for women, for ourselves, that is at once more difficult, more complicated, more fragile, more exciting and more likely to change the world.

Feminists in Britain have been fighting for women only everything for a long time. Now, it's a movement staple, what we've all come to expect. The meaning and intention of our coming together is rarely mentioned. Women only activity is being co-opted, used as a meaningless talisman to recruit for and validate any old liberal crap. This process not only adds lustre (and wo-

men) to traditional campaigns but tarnishes and distorts the significance of feminist autonomy. The political meaning of lesbianism has emerged through an analysis based on this significance.

Of course, there have always been lesbians, strong lesbians, proud to be lesbians. The assertion that lesbianism is *necessary* to the liberation of all women, however, is new and born out of the women only women's liberation movement. It seems to me that one of the effects of the women's peace movement, of 'Greenham', will be (may already be) to obliterate this vital analysis. Many of us who became lesbians via the women's liberation movement have now lived as lesbians for some time. We have had to feel, to know, the enormous negative pressure against lesbians that other lesbians have always endured and understood. We can't or won't go 'straight' now. But, as with some 'old dykes', the lure of a little acceptability is the lure of balm to the wounds inflicted by anti-lesbianism. Going to 'Greenham' is, after all, being seen to be on the side of right, on the side of peace and goodness and 'natural' women. And, for the moment, some of them in the peace movement seem to like us. Well, why shouldn't they? When dykes go to 'Greenham' they go to be good, to save rather than change the world — just like everyone else.

The women's liberation movement has been active in Britain for about 14 years now. In a very real sense that's very young, just a beginning. In another sense we've been around a long time; the initial euphoria is gone and there are complicated, thorny problems *within* the movement. Many of us are tired as well as challenged. The necessity for each woman who becomes a feminist to start at the very basic beginning, to analyse the situation of women for herself, has become as much an obstacle to a unified movement (of old and new feminists) as it is an important means of insuring commitment.

Currently, the issues of race and class are being seen as difficult and divisive as well as essential to feminism, to feminist practice. Feminism has not yet changed the world for women, not yet altered the way race and class operate among us. It's not

surprising that many of us are discouraged, uncomfortable. Other movements, like socialism, have fixed theories and programmes dealing with class and race that have naught to do with feminist process but which are now being reiterated and grafted onto women only activites. Yet, many of us remain dissatisfied by these knee-jerk responses and challenged by the reality of racism and class bigotry among women. The good feeling of women together, united in a common cause is rarely there in the WLM now. It, our movement, has become more various, more complex, full of challenges, full of disputes. The notion that the battle against nuclear power can unify us, can make us forget, or at any rate put aside, our differences, can be very attractive. That attraction is there not only as a possible breather for white middle class women.

As a Jewish woman, I feel very vulnerable in the WLM just now. I have always felt oppressed as a Jew. That's no different now. What is different is the notice being publically taken by other feminists. 99% of the time it highlights anti-semitism, makes me feel worse (at least in the moment). Sure, I know it's necessary to challenge the preconceptions of anti-semites, a painful process that can ultimately make things better. But it *is* a painful process. I'd rather not be reminded all the time of just how many women hate Jews/are racists. In the peace movement none of that need arise. Everyone will seem to be just together again. spurious. meaningless. cosy.

It seems to me that the women's peace movement is, in truth, one enormous, seductive con — a splendid method for eliminating the women's liberation movement. I've named only some of the ways in which 'Greenham' is used to hive off feminists and feminist analysis and action. The women's peace movement is so entirely *within* the existing system, the system of men over women, that to point out the flaws in its functioning is to rail against the status quo, to reiterate basic radical feminism (ie. we do not petition men to change, we do not demonstrate & go gladly but complainingly to jail, glamourised and gratified by notice in the press, we do not focus on men, we concentrate on women, etc., etc. . .).

For years now, I personally have deliberately not engaged in trying to convince others. I've concentrated my energy on women, on working to strengthen us, to building a feminist world without starting over again daily. (Please, no bullshit now about how that'll be irrelevant, if we're all incinerated first. I KNOW that nuclear power will only be stopped if men are stopped altogether. What we suffer everyday — rape, clitorectomy, unequal pay, the lot — while men speak of bombs they haven't detonated in 40 years — must be removed. Kicking daddy in the shins has never been very effective. Only women working together FOR WOMEN will actually change the world.) Now, however, it seems to me imperative to speak out. The women's peace movement, 'Greenham', is co-option on a mammoth scale, a real threat to the women's liberation movement. The deep appeal of what seems immediacy, the pull of concepts as simple and obliterating as life and death put paid to the suffragettes. It mustn't happen again. I need a women's liberation movement. We all do.

Lilian Mohin

SUPPORT THESE WOMEN FOR THEIR CHILDRENS SAKE DIRECT EMOTIONAL ACTION AT GREENHAM COMMON: A CRITICAL PERSPECTIVE

I didn't go to Greenham. Having spent a considerable amount of time during the past few months defending this decision against what, at times, amounted to a torrent of moral outrage, my initial uneasiness with various aspects of the politics, strategy and public image of the Women's Peace Movement (WPM) has developed into the following analysis of the Greenham ideology. I originally thought the problems lay in relatively 'superficial' areas such as press reportage and reformist methods, more recently I recognised that these were related to the silence which seemed to exist in an un-thought out 'gap' between feminism and the nuclear issue, in exactly the place I would have expected to find a whole 'web'(!) of connections. I began to doubt the adequacy of the explanations of this relationship I was offered, connections were assumed rather than examined, and this lack of understanding given political credence by the moral imperative, the sense of urgency and the emotional emphasis current in the WPM. I had always assumed that, fundamentally at least, I was in agreement with CND, and more particularly the WPM, until I began to think about those very 'fundamentals' and to see their flimsy content as both politically naive and irrelevant. 'Peace' as a unified concept and an absolute good began to seem meaningless, surely there are a multitude of possible 'peaces', and by no means all of them imply the downfall of male supremacy, or any other political changes which would amount to a 'good peace'. The value or otherwise of mass movements organizing around something as nebulous as 'not war' is not however the focus of this article; rather I want to look at the view of women underlying the strategic practices of Greenham. I think that this view is both an inevitable correlation of those practices, whatever the perspectives of individual women involved, and that it is untenable for us as feminists. I believe that this needs talking about now, and not brushing aside becauses 'we might not be here tomorrow'.

The WPM has put a good deal of emphasis on its strategy and training for non-violent direct action (NVDA) has comprised

much of the activity of WONT groups recently. However, the problems with NVDA have been discussed elsewhere, and I think the other more traditional pressure group tactics employed also raise interesting issues. Marches, petitions, letters (chain or otherwise) etc. are built-in features of western democracies, commitment to them implies faith in the myth that if enough people stand up to be counted a government will be forced to take notice of those it supposedly represents. As feminists we are well aware that governments do not represent our interests. The making of 'requests' within the above framework implies faith in the status quo, a status quo rejected by radical and socialist feminists alike as ultimately founded on unacceptable oppression.

If women in the WPM believe that pressure-group tactics can have a real effect, surely they must consider that the 'voice of the people' most likely to be listened to is a male one — so why organise autonomously? Either the reason for organising as women is a divisive dislike of working with men, or there is some reason to believe that women *as women* will be listened to. If the second reason seems more tenable, the question is raised of why a government should listen to women. Surely not because they are recognising their responsibility as men for this 'destructive extreme of patriarchal violence', but rather because the WPM fits into an extant pattern for women. Here can be found the eternally feminine nurturer and peacemaker, whose emotional, but none the less passive, response includes the traditional self-sacrifice for the sake of others, and most particularly for her children.

The position that as women, with all the attributes of female gender accorded to us in this culture, a claim can be laid to an officially recognised gender specific voice, raises two issues, firstly, the way in which it is taken up by men (media, CND, anti-sexist/Left,) and secondly, the issue of what sort of feminism informs an acceptance of such 'gendered' attributes.

In relation to the first issue, a male socialist acquaintance was reported to say that every time he saw the Greenham women on the television he was so moved that it brought tears to his eyes

— that he knew the rational arguments against Cruise, but that the emotive approach of the WPM is much stronger. As one friend responsed: "The WPM must not be debased to provide the 'soft' appeal for CND, while men give the 'hard' sell of rational argument". If CND and the male Left are supporting women's peace camps we can be damn sure it has nothing to do with feminism, but rather they have discovered, as plenty of others before them, that the mother and child icon pulls heartstrings. How, as feminists, can we stand well screened behind an image that is both untrue to most of our experience, and so clearly answers an emotional need that men have. CND's decision at their last conference to support NVDA is based on the belief that 'the people' are fed up with strikes, (hence the toning down of union mobilization,) and have become immune to mass demonstrations, but will support women being beaten up and thrown in jail — especially if they have children crying in all the papers. If much of the practice of the WPM is supposed to emphasise the importance of means to ends: "In all types of political activity the means determine the ends: and the goal of peace can only be achieved by means that are themselves peaceful."[2], then how can feminists accept the serving up of a femininity they have presumably rejected, as a means for getting rid of nuclear weapons? I can only assume that the WPM as a whole is informed by a feminism that embraces rather than rejects such a femininity.

It has been argued that it is the media that has constructed the image of the Greenham women as nurturing earth-mothers defending their children's future by an entirely appropriate passivity. Although in Peace News recently it was argued that the press, in choosing an elaborate collection of military metaphors to describe events at Greenham, constructed an image in direct conflict with the attitudes and actions of participating women.[3] It seems to me that a second look at some of the descriptions, ie. '30,000 strong army of housewives and grandmothers' (The Sun,) shows up the ironic tone in which the papers pointed up the 'natural' contradiction between being a 'soldier' involved in 'tactical struggles' and being a housewife or grandmother. Even the Daily Mail reported events fairly sympathetically, if patronisingly, but none to my knowledge took up the

feminist perspective. They could swallow the women-only stance because it fitted into a pre-existing image of womanhood, they didn't have to invent it, on the contrary, it was offered to them on the perimeter fence along with the baby clothes and family albums.

The WPM didn't invent this 'sort' of feminism which first accepts the feminine attributes which are supposedly given to women 'naturally', and then proceeds to glorify them; on the contrary it has a long history. Conservative suffragists who comprised the second phase of the 19th Century radical women's rights movement, most particularly in the USA, used the arguments around women's special qualities in order to win the vote. Women advertised themselves as guardians of political purity, the 'housekeepers of the world'. Again at Greenham we find women stating that they have a special relationship to the preservation of life. (Arianna Stassinopoulos said it in 1973, and the male press loved her.) This new version of old lies about women does not make the pedestal any less unreal, it is important that we recognise fully the reactionary implications of statements like that of Helen John's: "Feminists have to face the fact that the vast majority of women will always be child bearers and carers."[4]

One of the best selling WPM books 'A Handbook for Women on the Nuclear Mentality', the very title of which suggests the problem is merely an attitude of mind, states in its introduction: "While we do not want to insinuate that the masculine is necessarily all bad, we do believe that the dominating force within all of us which we label animus or male has taken over and created a destructive imbalance on our planet. We feel strongly that the value of anima or female energy has been largely lost to each individual, man and woman, and certainly to the earth as a whole. It is our intention, therefore, to illustrate this imbalance, and to suggest ways for restoring the female principle."[5] The hypothesis of some pre-social state in which men and women have equal quantities of animus and anima (what these are comprised of is never explored) makes such psychological specifications in place of an analysis of power no less reactionary. Even when the call is overtly to politi-

cal action, the language takes us back again and again to a
quasi spiritual evolution divorced from real conditions of social
change: "Could it be that just at the moment masculinity has
brought us to the brink of nuclear destruction or ecological
suicide, women are beginning to rise in reponse to the Mother's
call to save Her planet and create instead the next stage of evo-
lution?"[6] Much of the Handbook refers to the seperation of
man from nature and the identification of women with the
values of an ancient woman and nature centered society. The
idealisation of a past time, whether it be the supposed matriar-
chal tribe of pre-history or the romanticised medieval village,
is not just a-historical or inaccurate, it is politically dangerous.
It is not necessary to take Firestone as gospel and regard nature
as part of the great conspiracy against women in order to see
the reactionary implications of the identification of women with
nature. As with the argument about emotion, it is reductionist
and leaves us at source with a biologism that has always been
used against us, and which in its fundamental stasis of original
difference offers little hope for revolution.

I do not think I am likely to be convinced that nuclear power/
weapons is a specifically feminist issue, but I would very much
like to see such a case argued instead of assumed. The 'cultural'
feminism which I regard as informing it has been exposed many
times in the past as diametrically opposed to radical feminism
(and also to socialism), I think therefore there is something
specific to Greenham & etc. which enabled it to draw in so many
women of both these persuasions; this too needs further dicuss-
ion. Whether the nuclear issue is the most significant emblem of
patriarchy or not, we do not, as yet, have a power base from
which to challenge it. The WLM has always emphasised the
everyday as our starting point, let's get back to tunneling
beneath the structures, and acknowledge the inadequacies of
tactics which involve requesting men to dismantle their power
from the top. Such tactics cannot be divorced from a certain
acceptance of the status quo, a refusal to accept the realities of
male power, and a reliance on male constructed images of wo-
men.
 Sara Scott 7th February 1983

1. Democracy presumes itself gender blind — it is not. By people do we mean women
 as well, if we know only men are 'counted'?
2. Angela Philips, The Leveller No. 91.
3. Lucinda Broadbent, Peace News No. 2187.
4. Are we supposed to swallow Jung entire, misogyny and all?
5. Jane Alpert, MS No. 8.
With thanks to Diana for the conversations without which . . . etc.

30

Over the past several months I have become increasingly alarmed by the lack of feminist analysis of the women's peace campaigns and by the amount of energy that feminists are putting into these campaigns. They are publicised and seen as women's campaigns. Fine. But this creates the assumption that they are about women's liberation. They are not. At least not as far as I understand Women's Liberation.

My involvement in Women's Liberation has been primarily to liberate myself from male oppression. That involvement has meant my trying to understand the ways in which that oppression effects every part of my life and indeed the lives of all women. It has also meant that I have to put fighting my oppression as a woman first. To do this I have to take myself and my demands seriously. It is only by doing this that we as women can begin to make a future for ourselves. Our energy is too often diverted into campaigns that are about or for other people. In this morass of fighting for others we easily lose sight of the importance of fighting our own oppression and that this has been and must continue to be our first concern. Our strength as a movement and as women within the Women's Liberation Movement has derived from our common fight against our common oppression. That oppression is our oppression as women. I would like to ask what the Women's Peace Campaign has to do with our oppression as women. Yes, of course, nuclear war threatens women but does that make fighting for peace or peace itself a women's issue? What has this campaign specifically to do with women? I have yet to see any analysis of how nuclear arms oppress women in particular. Of course nuclear arms are an outrage and an extension of male power but that power will affect all and not just women. The oppression of women will not diminish one iota by the destruction of nuclear weapons. So what is the women's peace campaign going to change for women? Nuclear arms are a symptom of the madness of the patriarchy not the cause of our oppression. The suffragette movement's energies were co-opted and effectively dispersed by a great call to either fight for the country at war or to fight against the war for peace. Does the current peace campaign and the feminists who are involved in it mean that the Women's Liberation Movement's energy is to go the same way?

31

In addition what is this peace that women are fighting for? It can only be an illusion. There has been no peace (if peace is the absence of war) for centuries. There are wars currently in progress all over the world. Not in this country it is true, if you ignore N. Ireland. So what peace is it that women are campaigning for? Is it for themselves or for the women in other parts of the world? And is this peace for women or for everyone so that when peace is won women can return to fighting the lesser issue of their own oppression? Or perhaps peace is a continuation of the status quo with an absence of nuclear weapons?

The women's peace campaign is assumed to be part of the Women's Liberation Movement because it is a women only campaign. This assumption is made not only by the media but by many women involved in the campaign. Does that make any single sex campaign when that sex is female a feminist one? My mother is part of a group of women who work for Life and a member of the W.I. ; does that make her or those groups feminist? In addition the women's peace movement being seen as part of the Women's Liberation Movement has enormous implications for the W.L.M. Firstly, the W.L.M. is now seen as acceptable because women are concerned with saving the world. We are only dangerous as women and challenging to the world when we demand control of our bodies or when we have demanded the freedom to make choices in our lives. Especially we are not respectable when we express our sexuality openly as lesbians. These are all issues which are for ourselves as women. But ask for peace and suddenly the world not only takes women seriously but falls at their feet. Perhaps because asking for peace fits in with the traditional role of women as nurturers, carers and saviours of the world. Women risk a lot as feminists. It is a day to day struggle. To fight for peace is safe acceptable and condoned by society, whether that society be male or women who do not identify with or as feminists. Secondly, many of the women now involved in the peace campaign are not only using their limited energy in fighting for peace but are seeing their own oppression as subsidiary or secondary to that of the rest of the world. What would happen if all that energy was directed into the W.L.M. in order to build a future that is truly feminist? It is a long hard struggle fighting an oppression that is so much a

part of our culture that it is difficult to identify at times, but the fight will continue, it will just take longer if our small energies are continually diverted into other struggles.

Greenham Common obviously has enormous appeal. I can see that attraction and am aware of the energy generated by so many women being together. I can also understand the appeal of direct action. What I don't understand is what Greenham Common has to do with women's liberation. Perhaps it is easier to go to Greenham Common than to continue to fight our oppression. It is certainly easier than facing some of the problems in the W.L.M.

Jacky Bishop

Sometimes I feel that all I ever do is criticise things that women do, to dampen their energy and enthusiasm. I've been especially aware of this around the whole Greenham issue as I've been seen as being so hard and unreasonable in not supporting an action that almost every 'thinking' and 'feeling' person approves of. Most of the time, when talking to supporters, I've felt that I've been talking a different language, just not getting through. One problem is that I talk about where the action fits in with feminist politics, about the wider issue of the struggle for women's liberation and not just stopping the nuclear holocaust (Yes — I think that stopping the holocaust is easier that liberating women). Greenham supporters, on the other hand, seem to get caught in the excitement of it all; fear of the threat, the action, the glory and the sense of achievement of the action. We are talking about two different things. Things can get so messy in the whole debate that its useful to make a clear distinction between these two ways of thinking/feeling about it.

My list of theoretical objections is long but some points have been well dealt with in other papers. The fundamental belief which affects my thinking on Greenham is that it is a mark of the magnitude of our oppression that it is often invisible and unspoken; feminist issues are not even recognised as being issues by the vast majority of women and men. There is constant denial of the importance of our struggle not only from outside but from within ourselves; our lack of social approval wears us down, we need recognition and rarely get it, we find it easier to work for others who are always worse off than ourselves, we don't want to become monsters, hard, inhuman etc. etc. etc. I believe that one of our main objectives must be to make our oppression an issue, visible to all women; to raise their consciousness of this and to maintain our own, alive and strong against the forces which seek to destroy it. I don't think that Greenham does this; it's based around a recognised human issue and does not explore ways in which we are oppressed as women.

Greenham is another issue that is more important than women's liberation. Like Ireland, Chile, the National Front, El Salvador, it is urgent/important/immediate and has the added appeal of

34

real social respectability. Like the other issues too, it has been defined by men and has their seal of approval as a 'real' issue. Oppression is bad and ugly but we can't blindly go and fight every evil that is presented to us. Things haven't changed much, as Ti-Grace Atkinson pointed out in Amazon Odyssey (1974):—

> Without a programmatic analysis, the "women's movement" has been as if running blindly in the general direction of where *guess* the last missile that just hit them was based. For the first two years of the last organising, I was very active in this running-blind approach. It's true that we were attacking evils, but why *those* particular evils? Were they central issues in the persecution of women? There was no map so I couldn't be sure, but I could see no reason to believe that we knew what the key issues were, much less that we were hitting them.

Greenham and the whole nuclear issue is a diversion for women. We can't have women's liberation if the whole world is blown to bits, therefore forget our struggle and join together . . . We can't have women's liberation until after the revolution, therefore forget our struggle, join together . . . Sounds familiar?

The whole campaign against the arms race is based upon naive democratic notions that if enough people are against something then governments will change their policies. We are asking the men in power to change. What's more, we are asking them as mothers, women, peace bringers on behalf of humanity, our children and future generations. That's why Greenham is so respectable: it's not challenging anything.

I don't want to get into answering all the statements made by Greenham women and WONT groups but I do want to deal with the idea that the nuclear issue is a women's issue because militarism is a visible symptom of male supremacy. That's not an amazingly revealing statement — man the war monger, woman the peacemaker. Women know that men are aggressive; what's important is that we begin to make connections between their aggression and our oppression and work out ways to fight our oppression. Greenham points out that men are aggressive but doesn't go any further. The campaign actually utilizes traditional stereotypes of women to achieve short term gains. That is

not consciousness raising. We can point out that men do bad things, women have always said that, but without a feminist analysis/context we won't get far.

Having said all that, I don't want to dismiss reasons why women went and the experiences they had at Greenham. What I sensed while listening to women's accounts was a feeling of elation, excitement of action, of working together, doing something that's well organised and is recognised as being important. It reminded me of my mum's account of the war, everyone working together under adversity and of my aunt's experience in the Land Army. It's important that women work together, explore our limits, our strengths and weaknesses. It's a positive experience, but like the Land Army, the Girl Guides, the W.I. or wherever else we come together, without an overt feminist context with which to make sense of our experiences of shared oppression and shared strengths we are left powerless and confused in a male world that we can't even recognise as not being our own. Single issue campaigns like Greenham are always popular for a short time, then they fizzle out and many of the women involved fade away in disillusionment because the questions weren't answered, the methods of working weren't consciously feminist and the connections weren't made.

I understand though what has made many feminist women get involved in Greenham and go along on the day of action. It's a real reflection on the depressed and liberalised state of the movement that a highly organised, well financed and respectable non-feminist campaign can attract so many women. Our politics are discredited and undermined by the rest of society including the alternative and radical left and from within by promotion of the individual solution (therapy, self sufficiency, feminist enterprises etc.) Our confidence and feeling of control over our own environment is undermined as more and more feminist events, from discos to workshops, are organised for us by specialists. The list is endless, so Greenham isn't all that surprising.

What I'd like to see coming out of this workshop as well as a coherent radical feminist critique of Greenham is a future

series of workshops to look at the present state of the movement and of feminist politics. Hopefully this will be a way of creating a stronger movement once more and of ensuring that we are not so easily diverted from our feminist politics in the future.

Brenda Whisker

GETTING OUT OF GREENHAM . . .

Taken from Merseyside Women's Liberation Newsletter

Dear Sisters

Can it really be that we all accept that Greenham and the Women's Peace Movement are just simply a good thing? Perhaps a number of us did groan with horror at the over indulged media coverage, but how many of us are prepared to stand back from the general euphoria and actually look at what is happening? My own initial unease about the sentimental focus that the December action took has hardened now into a firm belief that both the explicit aims and implicit compromises of the peace movement must be challenged. I wouldn't deny that the experience of many thousands of women coming together and successfully staging a mass protest provides a tremendous buzz but I am worried that the buzz has taken precedence over any clear analysis of the whole issue.

A primary problem perhaps is that any alliance tends towards a lowest common denominator and while the nuclear threat in all its manifestations is clearly a major issue, there is very little else that we would agree on except that we all wish to protest at our imminent destruction. And however radical/revolutionary one's own feminism, there is no denying that men are equally at risk from that threat. That women should demonstrate en masse does not make it per se a women's issue, and the widely tolerant, even benevolent, attitude of the media must surely indicate that there is no force in any marginal inditement of men as the perpetrators of nuclear power. (And please can I be spared the fatuous protests that the Prime Minister is a woman). Indeed how could there be when so many of the women involved would not agree to a condemnation of anything more abstract than government policy. The only really hostile reactions coming out of the media seem to be largely directed at the disturbing (to them) visibility of lesbians at Greenham; but by and large the sight of women protesting about something that threatens practically everyone alike has not presented any significant challenge to male power.

38

The overall aim then can be nothing more specific than a rather nebulous concept of peace, with the more immediate goal of preventing cruise missiles from being sited in this country. That this in itself is a serious matter which has temporarily involved a great many women in real hardship speaks only of their admirable courage and determination and very little of their feminism. And in this lies my belief that far from challenging the machismo of the nuclear mentality let alone following through the implications of that, the Greenham Common syndrome poses a real and growing threat to the continuing viability of an autonomous Women's Liberation Movement.

It is many years now since the word 'Liberation' was dropped in common parlance in favour of the less threatening Women's Movement; and I feel that while feminisim is being almost exclusively publicly defined in terms of the peace women, it will not be long before feminism is the Women's Peace Movement. And that in turn, while it continues to offer no unified critique of male power, is subject by the very universality of the nuclear threat, as no other women's campaign has been to usurpation by men. The undifferentiated Peace Movement beckons and as feminists I believe we must resist it.

Many women of course will see opposition to the nuclear threat as their major committment and in so far as I believe that Feminism must undermine the excercise of male power in as many ways as possible I would argue only with their analysis, not with their personal priorities. But one major question must surely be answered by all women who direct their feminism into a peace movement: whose peace will be achieved? I am certain that the 'peace' that would be achieved by the utopian total abolition of all nuclear technology would still not be my peace.

As a woman I am engaged in a continuous war that has little to do with the existence or otherwise of nuclear plant at Capenhurst or cruise missiles in Greenham. It is a war waged on me every day of my life by men — including the nice understanding anti-nukes men who didn't muscle in on the Greenham activity. None of us as women can afford to defer our fears in line with the non-deployment of Cruise, the dismantlement of SS20s

whatever; we live under constant threat of battering, mutilation, rape, and murder. Personally I fear any of the latter more than I fear nuclear destruction and it would be disastrous if the energy of feminists were to be largely diverted from the fight against such immediate violence into the soft centred goal of propping up their peace. Let's make it plain that men are the perpetrators of violence in all spheres, and stop now the thoughtless clamour to promote peace as the only worthwhile goal.

Holding hands and weaving webs is not enough. While you are getting your sisterly buzz with yet another trip to Greenham I am walking up the street wondering if I'll make it to my front door or behind it. I want freedom from all male violence, not a variety of 'peace' I want women's liberation.

Margrit

Dear Sisters,

I want to ask you some questions about the politics of what you are doing. Nothing I have read of yours has made me feel I really understand why feminists are going into these campaigns. My concern has been mostly set off by reading *Nuclear Re/Sisters* by Feminists against Nuclear Power* and more recently by reading the Women's Peace Alliance's statement of aims.**

It is very difficult to ask questions about campaigns against nuclear power/for peace — they tend to take on an almost holy status, and you feel you are just being perverse — or there's always the suspicion that you haven't understood the risks. . . I want to make it clear that I believe that it is highly likely that nuclear power in one form or another will produce either total destruction or slow poisoning for us all in the near future. The issue I want to discuss is what can be done about it — and especially whether for women to involve themselves in existing campaigns, or to replicate these campaigns in women's groups, is a useful thing to do.

So — some questions:

Is nuclear power a feminist issue?

What is a 'feminist issue'?

Men created nuclear power. Is a group of women opposing it then inherently feminist?

Nuclear power is the highest, maddest expression of patriarchal reasoning. Is it wise for us to start at the top?

When we are denied rights over our own bodies, how can we fight for everyone's survival?

What is the strategy you propose? Is it a distinct, feminist approach, or are you adding your voices 'as women' (whatever that means) to E.P. Thompson and Co.'s movement?

41

Is the new Women's Peace Alliance really what it appears to be, an alliance based on keeping quiet about women's oppression? It seems to me that an organisation with no stated commitment to women's liberation has no place in feminist publications such as *WIRES*.

Do the women in WONT see feminism and the fight against nuclear power as quite separate issues, as those who wrote *Nuclear Re/Sisters* seem to — or do they think women have a different relationship to nuclear power than men? If not, why are they working in women's groups? The only reason given for this in the *Re/Sisters* pamphlet is that it is more comfortable not to have to confront men all the time.

So what are the problems with the CND (Campaign for Nuclear Disarmament)-type strategy?

What does it mean for feminists to use reformist methods — marches, petitions, etc . . .? It implies that we (the people?) (women?) have the power to change it — now. It implies considerable faith in parliamentary democracy.

What you end up with, I am afraid, given our present government, is essentially support for a Labour Party committed to unilateral disarmament by a Party Conference.

Does that remind you of anything? Was it the '64 Labour government that was elected with a disarmament programme?

They lie.

Surely you know they lie?

Has anything changed since the last mass-scale CND campaign? From the developments in the arms race since then I can see grounds for panic, perhaps, but no new grounds for hope. What is new is a world recession producing yet more insane (democratically elected) governments in many Western countries.

Is nuclear power to be seen as the ultimate expression of patriarchy?

Then what's the sense in women trying to put a stop to it without destroying patriarchy? Men have not often been seen to give up power voluntarily. What makes you think they'll give up the greatest power they have harnessed? Someone has to find a power base from which to challenge it.

Ending male domination begins with women developing a sense of our identity as women. With focussing on what we have in common as women. A primary empowering step is to see that we are not deficient men, we are different from them and oppressed by them. An important political act is to stop taking on guilt for the crimes of men — it is they who made this world as it is. We have to start from where we are, recognize what power we have and what we do not have and will have to fight to achieve.

It seems to me we should be trying to unpick the power structure from the bottom.

How do women in WONT and the WPA see us gaining the power to make real changes?

An alliance based on femaleness saying nothing about female oppression?

An alliance with nice men in the hope that 'enough people' can sway the power elite towards sanity?

I hope that the women I am writing to will not see my questions as negativity — I want to see these issues debated.

My fear is of large numbers of women abandoning women's liberation struggles in favour of what is seen as a 'larger cause'. It runs deep in all of us to put aside our 'special concerns' for the human race. My anxiety is particularly intense because my own involvement in similar campaigns in years past has led me to an interpretation of the world which makes me think

that the fight for the 'larger cause' as it is currently being fought will only lead to frustration.

The parallel that haunts me is with what happened to the first wave of feminism in this country when the First World War began. I want to be reassured that this is not an appropriate parallel.

Sophie Laws

Nuclear Re/Sisters, by Feminists against Nuclear Power, c/o Sisterwrite Bookshop, 190 Upper Street, London N.1. Price £1.00, 25p for postage and packing.

**in *WIRES* No.118, September 1981. *WIRES* is available from P.O. BOX 162 Sheffield 11UD for 30p.

From *Catcall* issue 13, December 1981.